Twenty-One
about Wonky Animals

ex libris

Candlestick Press

Published by:
Candlestick Press,
Diversity House, 72 Nottingham Road, Arnold, Nottingham NG5 6LF
www.candlestickpress.co.uk

Design and typesetting by Craig Twigg

Printed by Bayliss Printing Company Ltd of Worksop, UK

Cover illustration © Jane Burn, 2023
https://janeburnpoet.wordpress.com/

Candlestick Press monogram © Barbara Shaw, 2008

© Candlestick Press, 2023

Donation to Manor Farm Charitable Trust
https://www.manorfarmcharitabletrust.org/

ISBN 978 1 913627 31 7

Acknowledgements

Thanks are due to the authors below for their kind permission to use their poems,
all of which are published here for the first time:

Sophia Argyris, Anna Barker, Carole Bromley, Jane Burn, Linda France,
Victoria Gatehouse, Leah Larwood, Rob Miles, JLM Morton, Nora Nadjarian,
Caleb Parkin, Mel Pryor, Amber Rollinson, Johnnie Sparkle, Hannah Stone and
Sarah Ziman.

The other poems in this pamphlet are reprinted from the following books, all by
permission of the publishers listed unless stated otherwise. Every effort has been
made to trace the copyright holders of the poems published in this book. The
editor and publisher apologise if any material has been included without
permission, or without the appropriate acknowledgement, and would be glad to
be told of anyone who has not been consulted.

Thanks are also due to all the copyright holders cited below for their kind
permission.

Kathryn Bevis, *Flamingo* (Seren, 2022), by kind permission of the author. Tania
Hershman, *Still Life with Octopus* (Nine Arches Press, 2022), by kind permission
of the author. Clare Shaw, *Towards a General Theory of Love* (Bloodaxe, 2022)
www.bloodaxebooks.com by kind permission of the author.

All permissions cleared courtesy of Dr Suzanne Fairless-Aitken
c/o Swift Permissions swiftpermissions@gmail.com

Contents

Fox names the world

Fox calls the night *solace*, calls the stars *home-light*
calls the clouds her *fickle friends*. Fox calls
hedges *hatchways*. Her claws chatter like teeth
on the road, she calls concrete *strange stone*,
hears her own steps on its grey skin, pauses,
scents the air again. Fox knows

some places are too dead to hunt in,
nothing warm blooded can live where
the *strange stone* rises too tall, leans too close,
but she can slip between the looming jaws
of these mountains, find little bits of life.
Fox calls rat *hope* or *taste* or *joy-fur*.

Sometimes she finds other things to eat,
things left lying, often wrapped in tasteless
shuffle-mouth stuff that must be shaken off.
Fox moves in silence, calls the dark her own,
haunts the dimming sky with her voice to say so.
Fox calls the world *fierce, gladsome, mine, known*.

Sophia Argyris

Sighting

A quick black cinder in the sky.
A hungry mouth.
Scrap of paper left after snipping a silhouette.
Letter in an unknown alphabet.
An ancient blade, scorched.
Secret of the night.
A word thrown over a shoulder.
Coffin for insects.
A stretch – yawn – untethering.
Spring's shadow.
Woken too early, a dream broken.
After the equilux, nox.
Nox, silent nox.
The headmistress's robe.
A windblown leaf.
A figment.
Reflex, reflux, redux.
The eyeliner flick.
Anthracite (endangered), sky set alight.
Your chiffon dress with the pointy hem.
Moon's familiar.
Pocket-sized, sleek.
Dusk-grazer, sky-blazer, black-laser.
Velvet and skin, wrapped (unwrapped).
Kepler's five-petalled rose.
Our edge – not hers, spinning her centre.
How to love the sadness and not know where it goes.
A skein of afterimages, Rorshach, mystical.
You can't always see it.
You can't always see.
Blind as.

Linda France

To listen for a mouse

means to get mouse-like, and a mouse
must know its own sound better
than the many bigger beings, better
than any system set
for its detection. A mouse
must calculate the weight
and tension of its very soul, the tickling
resonance of its ribcage, any
tendency or potential
for scratchiness; it must match claw
and grip and speed to the depths
and textures of all surfaces.

To listen for a mouse
means to map from memory
where you stood still last, or crept
to where something scuttled, to that place
another, not too dissimilar
and possibly even quieter
did not come back, not even
as a ghost, but had itself failed
to listen as if listening like a mouse
for what is inaudible to most, but is
in fact, that tireless siren singing
of the unsprung spring
of a trap.

Rob Miles

Crow

I watch you ransack a rabbit, though it's not 'til you flip it
I see the scut.
You show me the easy-in, an incision wide enough to bury your head
then up and up
under a skirt of skin to unhitch the lumbar vertebrae.

There's tenderness in your work, or precision. I pretend to
know the difference
while on a stone you lay the bags and pipes, find an end;
show me
the heart, the stomach, the spleen.

Looking at you, I see a surgeon, or an artist or
something in-between,
not the violence that frightened me so much I hid
until you'd preened
yourself clean.

Anna Barker

Smitten

At Castle Howard the peacock has fallen in love
with a metallic blue Mazarati. Already
he has broken off a wing mirror,
cracked the sidelight, dented the bonnet
but the car is unmoved by his full fantailed
display, the rattle and shiver of his train feathers,
the thousand dazzling eyes. He makes another rush,
his courtship dance impressive, desperate,
oddly touching. We've all been there, all laid out
our dazzling iridescence for a hopeless mate
with no more feeling than a clapped-out car,
though, in his defence, it was a beautiful shade of blue.

Carole Bromley

The zoo in my cellar

There's a GoPro
rigged up to the zoo
in my cellar, a direct line
to the editing suite, once the
lights pop out, the night vision
kicks in and chimpanzees break
into the Cognac. Baby owls start
swearing, pumas zig-zag across the
stairs, a flamingo makes eyes at a mop
vultures pick over regrettable conversations
and a tiger thwacks several shades of rage into
a feature cushion. Meanwhile, the snapping turtles
play ankle bingo and two Luna moths fly a figure of
eight over two quokkas discussing a new Netflix series.
A melancholic gorilla's writing in his diary. An edgy camel
searches for some herb. Lion's having a profound moment of
awareness about his friends, while zebra violins Dizzee Rascal's
You've Got The Dirtee Love. The hippos roll their eyes at the pandas,
the pandas roll them back across the floor. Old polar bear? He's simply
hanging in there. Yet only the meditating bat knows that this can't go on forever.
Watching everything there's a capybara, still as sunrise, holding a flute like a spell.

Leah Larwood

Still Life With Octopus (I)

There is an octopus in my chest, trying
to give my heart to you. She will not listen

when I say I need it. I have to keep
prying her from my vena cava, the pulminary

veins. I ask what makes her think
you'd want it anyway. She shakes her head, her colour

shifts to indicate disappointment, hope,
connection. Finally, I let her take it. Once

it's gone, she settles in its place, exactly the right
cardiac muscle shade. I worry about where my heart

is now, did it even reach you? Let go, whispers the octopus
in my chest. These things are not in your control.

Tania Hershman

Red dog blues

All tic and flutter, I see your forty-wink slumbered
rug-splayed jerks and snatches
worrying care-less squirrels, hurrying blousy wood pigeons
who fatly wing away with bob and flap.
Biting bright dandelion crowns -
oh, close your eyes and breathe in every twisting cord
of slash-bladed barley-sugared grass, every dogged inch.
A reeling sommelier, sloshed in cellars of your own scents
high on doggy sensi, you're in
so deep, all gone on vintage piss
a hundred feet tall and higher, chasing lions, leaping
with a million squealing children, a spiralling
dragon on a spinning carousel, a tongue-lolling ten-headed
beast with fire eyes and the burn of joy in every atom
a storming charioteer, a bold and brassy Boudicca
conquering all with breast beats and jaws and teeth
and not a slanty-angle gangled whelp beside the fire
twitch and whimpered knot-coat bony-legged
too big for your boots liver nosed mutt
forever queen in a starry-eyed rug top skirmish.

Johnnie Sparkle

No Hoof, No Horse

I do not know how to begin to grieve for you. Grief is as large as a hill,
as small as a mouse. I catch it in the corners of my eyes. It weeps down
the window like rain — lays its shape at the glass so that light cannot blink
the morning through. I'm afraid to open your stable door, lest I drop
into its well of pain. Afraid to sleep in case you are gone when I wake.

I remember how tiny you were! So many risks in offering a home to a wild,
unhandled foal. I wondered myself — did I know anywhere near enough?
Green on green makes black and blue, they said. At first, you were so afraid.
Instead of your mother, you got me. My first touch made your hide creep.
We have taught one another everything we know — learned so much

about kindness, patience, never giving up. You have never hurt me
and I hope I have kept each promise to you. For years you have been
my every day, my every thought, my everything. You're a mountain.
You're my heart. If you leave me now, what will I do with all this love
I have left? As you slump on the straw, your mane is made unkempt.

I smooth it down. *Is this the end?* I feel you ask. I see it in the dullness
of your look — exhausted, bewildered, resigned.

Jane Burn

Love Song for Ewe

No beast grazes a hill as I do, ruminating
on forbs and clover, the panopticon
of my rectangular pupils set in gold.
Count me, my lover, tup your coins.
For you I would kneel without lameness,
which is to say I'll remember if you go.
I'm on the run with all the lustre
of my fleece, I leap the gate,
make of the dell a fire in my wake.
The turn of a branch has nothing
on your improbable limbs, the pride
in the angles of your skull.
Follow me as I follow you
to each blade of grass.
We will eat in the noiseless altitude.
We will feast on the summit.

JLM Morton

What the herdsman said

As with the dove and the monkey, time withers
a goat's body but magnifies its soul.

A three-legged goat is a triad,
the noblest of goats.

Holy, holy, holy is the goat.

Its tongue is an instrument of laughter.

Its urethra contains starlight. Its heart –
a mountain, its tail – an angel's thumb.

During lactation, goats pray in the language
of the Milky Way.

The Sea of Galilee originated in a goat's
fourth stomach.

Neither a goat nor its seed should be offered
in sacrifice, even to the Lord.

Delight in all small pockets of wonder.

Those born in the year of the goat are kind.

Mel Pryor

Snailology

We live in slow motion, says Snail to her best friend. You realise we can never run away from our past? Our bodies are too sluggish. Why carry this burden on our back forever? The same house, the same mortgage. It's so crushing to be a snail. Her friend tells her to find a way to zigzag. Zig and zag are the meaning of life.

Snail plans to meet her lover and writes him a note: Soon, soon. The path is long, though, and progress is slow. Snail is tired of how slow it is when you love. Snail is tired of how slow it is when you don't love. It's a slow world turning on that soon, soon.

The heart of a snail can be anywhere in her body, beating in secret. Such a sweet heart, never complains, but explains the world in little steps. Oh Snail, here it is, your path. Here is what keeps you going. Just this earth to hold on to, no hands. Look, no hands.

Nora Nadjarian

What the Frog Taught Me About Love

Owl says look very hard for it.
Turkey says dance very well for it.

Goose says just be born to it.
Dog says roll yourself in it,

be governed by fear of loss of it.
Cat says you can always leave.

Chimp says you have to fight for it.
Lamb says leap for the joy of it.

Wolf says howl for it. Die for it.
Monkey goes mad for the lack of it.

Bowerbird says go to great lengths for it.
Penguin walks hundreds of miles for it.

Firefly burns very bright for it.
Frog just holds on. Tight.

Clare Shaw

Little Wing

Me? Part of the Hendrix clan, mate.
Straight down the brood line from Eve
on my mother's side –
Carnaby Street to Croydon, as the crow flies.
 Ponderously, since you ask.
Actually, don't put that in,
there's been some...tensions.
Local skirmishes and that.
Bad enough all that hoo-ha with the owls.
I don't want to go fuelling the fire, you know?
It's all tongue in beak.
 Anyhow, we weren't the first – never claimed to be –
but who wants to be the progeny of some back-parlour twitterer,
freed in the belief they had the plague?
One minute, old Ethel's giving you the *Pretty Polly* treatment, and the next –?
Cage open, nets drawn, and don't catch your tail as she slams the sash!
I'd rather be a bleedin' canary.
Psittacosis? Smoker's cough more like!
 The African Queen theory?
HA! That shower.
Yeah, a lot try to claim it, but I don't see what's so special.
They're as green as the rest of us, and no blue blood neither.
Bunch of luvvies, that's all. 'Bout as royal as a Mandarin duck.
But it's a universal impulse I suppose, what with every one of your cabbies
supposedly descended from Alexander the Great.
Invasive species is some properly divisive rhetoric.
 The point is, we're here now.
All of the whys and wherefores don't matter at the end of the day.
Put that in your *Birds Britannica* and smoke it.

Sarah Ziman

There are various theories – mainly apocryphal – about how the population of ring-necked parakeets in south-east England became established. One enduring favourite is that a certain rockstar released a pair in central London.

Hornet

Hench horror, I'd love
to love you but
you've been at the 'roids
again, hyper-pumped, hitting
this city for punishable
flesh to pierce. You saw me
once, in the shower, loomed
thickly through steam,
your stabby appendage
strapped to that warning-
tape arse. So, I crushed you
in my swimmers, *crunch*
against the glass. The heft
of you! Your freakish bulk!
You are the gruff one
in a zombie movie
who wants to toss
someone like me
out the fortified gates.
You're that boy who
lobbed a basketball
right at my face.
Let me in, you say,
thudding the cubicle,
thorax pulsing: *See
how magnificent I am,
in my mass, my fury.*

Caleb Parkin

Conversation with the Mole

He speaks of subterranean churches,
the sacred hush of tunnelled ground,

confesses it's all about the worms,
their luscious-pink squirm in the throat.

Sometimes he hoards them in chambers,
half-alive - to come back to later.
I admit I have poems like that.

My shoulders thicken,
a blunt, shovel-strength in my hands
as we swim beneath the earth

throwing up mountains

to dismantle and remake the dark -
root-scented corridors
in which insects hunker down –

startle of moth-wing,
of grub-shine, the coal-seam
backs of beetles, unfastening –

a glint of the language
I thought I'd lost.

I confess it's all about the words,
the way they hum larval on the tongue.

Victoria Gatehouse

Curiosities and Cavorts

I was charmed by the dwarves,
the strongest man flexing his muscles,
the ugliest woman in the world
but the bearded lady frightened me
and I ran from the calf with two heads,
the five-legged dog,
the three eyed sheep.
They were so sad.
That night I had a dream
and in it they escaped,
ran riot through the streets,
laughing at the rest of us
with our ten digits, our one brain,
our pale, hairless faces
our unambiguous sex,
our two legs hanging
in the usual places.
I dreamt they rounded us up,
herded us into a tent, roared
and howled and gawped
at our pride in all being the same.
I woke to the taste of wet straw
and a feeling that was new to me,
something like shame.

Carole Bromley

Who could see a tiger

who could see a tiger sitting on a bench
along the diagonal path through the graveyard

or in the window to some café, uneaten toast on the table
two circles of mist where his hot muzzle pressed

not burning bright, burning like a burrowing ember
burrowing deep into the forest floor

or in the street, hidden under a big coat
who could see a tiger everywhere she looked

behind her, in front of her, focused on faces
or some pattern in the lichen, or a feather taking flight

who could see a tiger on the bus, scratching
scraggly, orange ears, who when his stop arrived

felt it all going, out with the hiss of the brakes
and the swing of the door

who could chase the crumbs of him, looking
for signs in pale cherry blossom

settling on the image of her own whiskers in the rain

Amber Rollinson

Lessons from late-brood hoglets

Twentieth of October, 'Leon' weighs in
at 358g; 'Bailey' at 362. The well of your foster-heart
is deep, but foot-high tubs too shallow, you learn,
driving home, with hoglets nosing over the rim.

The cats are unimpressed at two new heart-beats
in this lockdown pad. You dream of steam-trains, snakes
with head-colds; beetles that click and whir and chirp.
You check online for 'sounds that hedgehogs make.'

Their snuffling and their snoring please you.

It is impossible to hog-proof water-bowls; they will
be emptied, soiled, upended. You need a new word
for the lightness of touch needed to handle
these prickly spheres, when you freshen their beds.

You stroke their spines.

You obsess about your hoglets; develop
Erinaceus europaeus pareidolia – see urchins
in clumps of dried grass, prunings from rosebushes,
sunflower heads drying in the greenhouse.

Twentieth of March, you lift them like votive offerings
to the equinox; they unwind in the sun,
turn widdershins, race away
from the foraged-brick house you built them,
up against the hedge. Now it's wee wee wee wee
all the way home.

Hannah Stone

My Cancer as a Ring-Tailed Lemur

We both know one day she'll eat me.
But, for now, we dance: a little game
of catch me if you can. Tracking her
is difficult. But specialists are interested
and, bit by bit, they creep inside my body's

forest, stalk her with their fancy cameras,
take images, write reports. On ultrasound,
she's punk-rock stripes of white and black.
On mammograms, she sunbathes, downy
as a dandelion gone to seed.

The child I am divines the time by blowing.
Five years, ten years, twenty, more. That's
when they spy her, up in the canopy,
her tail Rapunzel's plait looped
round a single sentinel node. Now, on MRI,

they spot her kindly spaniel's face
crammed into the lettuce of my breast.
At last, on PET-CT, they catch her
on the move. She's up and off alright: a lope,
a leap. She careens through my branches,

omnivorous for bone and liver, brain.
Because her nature is to double herself
again, again, she and her sisters huddle, tails
conjoined, tiny arms about each other's necks.
The child I am learns to prophesy afresh,

blows one year, two years, four years, five.
Friends say *this is war* and I'm *a warrior*,
a tower of strength. But the lemur and I
get on okay. I figure she has a right to be here.
She is, in some important sense, endangered too.

I draw the line at poisoning but let
the hunters starve her, most days. She looks
at me with orange eyes of ire as we witness our
habitat's destruction. My new need for naps,
my breathlessness – for both of us a forest fire.

Kathryn Bevis

Sanctuary

As if from nowhere it came,
the rickety old donkey,
blind as Tiresias and lame.

I thought this was a dream,
but welcomed the old donkey.
Come here, I said, and rest inside my poem.

Mel Pryor

Afterword

The Wonky Animals Poetry Collective are all poets who engage with life from an animal perspective and in doing so, generate a deeper humanity towards creatures, each other, and their own wonky selves.

They raise money to support the wonky animals at livestock sanctuary Manor Farm Charitable Trust by running readings, workshops and events.

You can find the Wonky Poets collectively on Facebook, and individually they are Anna Barker, Kathryn Bevis, Jane Burn, Tania Hershman, Caleb Parkin, Di Slaney and Clare Shaw.